CHRISTOPHER HART'S DRAW MANGA NOW!

Friends and Crushes

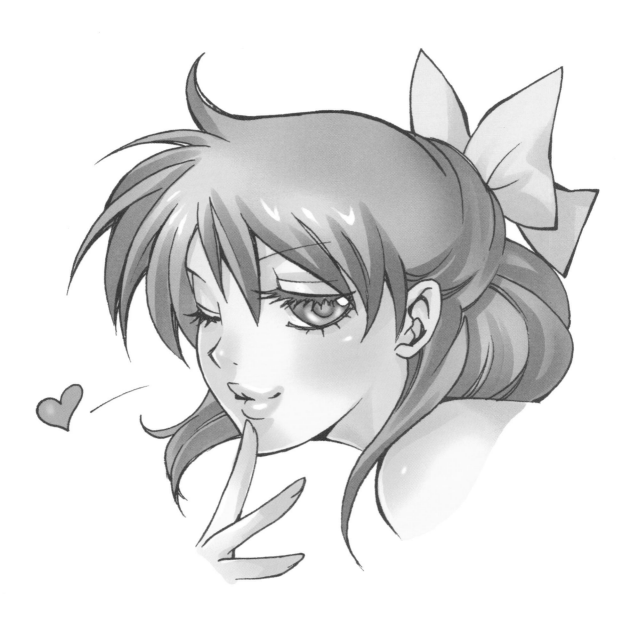

CHRISTOPHER HART'S DRAW MANGA NOW!

Friends and Crushes

Christopher Hart

Watson-Guptill Publications
New York

Published in the United States by Watson-Guptill Publications, an imprint of the Crown Publishing Group, a division of Random House LLC, a Penguin Random House Company, New York.

www.crownpublishing.com
www.watsonguptill.com

WATSON-GUPTILL and the WG and Horse designs are registered trademarks of Random House LLC.

This work is based on the following titles by Christopher Hart published by Watson-Guptill Publications, an imprint of the Crown Publishing Group, a division of Random House LLC.: *Manga Mania Shoujo,* copyright ©2004 by Star Fire LLC; *Manga Mania Bishoujo,* copyright © 2005 by Star Fire LLC; *Manga Mania Occult and Horror,* copyright © 2007 by Star Fire LLC; *Manga for the Beginner Chibis,* copyright © 2010 by Star Fire LLC; and *Manga for the Beginner Shoujo,* copyright ©2010 by Cartoon Craft LLC.

Library of Congress Cataloging-in-Publication Data

Hart, Christopher
 Christopher Hart's draw manga now!: friends and crushes/Christopher Hart.—First edition.
 p. cm
1. Human beings—Caricatures and cartoons. 2. Comic books, strips, etc.—Japan—Technique. 3. Cartooning—Technique. 4. Friendship in art. 5. Love in art. I. Title. II. Title: Friends and crushes.
 NC1764.8.H84H3655 2013
 741.5'1—dc23 2013028888

ISBN 978-0-385-34549-1
eISBN 978-0-385-34536-1

Cover and book design by Ken Crossland
Printed in the United States of America

10 9 8 7 6 5 4 3 2
First Edition

Contents

Introduction

Manga is all about relationships. A strong circle of friends is key to a good story in a graphic novel. Some friends are true-blue, some are jealous, and some have secret crushes on each other. We'll explore these in this fun-filled guide, featuring a wide array of character types, from chibis to shoujo and more.

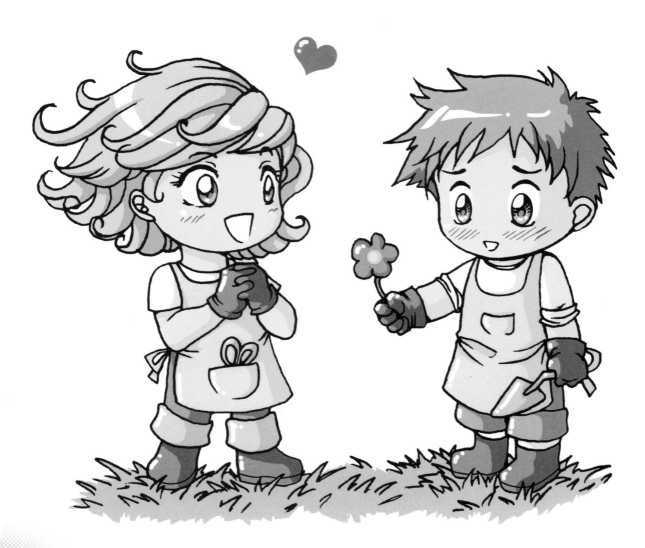

To the Reader

This book may look small, but it's jam-packed with information, artwork, and instruction to help you learn how to draw synergy between manga characters like a master!

We'll start off by going over some of the basic concepts seen in the romantic characters and scenes of manga. Pay close attention; the material we cover here is very important. You might want to practice drawing some of the things in this section before moving on to the next one.

Next, it'll be time to pick up your pencil and get drawing! You'll follow my step-by-step illustrations on a separate piece of paper, drawing the characters in this section using everything you've learned so far.

Finally, I'll put you to the test! The last section features images that are missing some key features. It'll be your job to finish these drawings, giving the characters the missing elements they need.

This book is all about learning, practicing, and, most important, having fun. Don't be afraid to make mistakes, because let's face it: every artist does at some point. Also, the examples are meant to be guides; feel free to elaborate and embellish as you wish. Before you know it, you'll be a manga artist in your own right!

Let's begin!

PART ONE
Let's Learn It

The Eyes Have It

The eyes are always important in manga, and when we're talking romance, they're even more so! They are essential to conveying characters' feelings for each other. Let's start here and take a look at what makes effective, romantic manga eyes.

Captivating Female Eyes

Eyes are the focus of the face and are more important to the expression than any other feature.

Most beginners use the same shape of eye for every female character they create. But eyes are not "one size fits all." Different character types require different eye shapes. A young girl will have a different eye shape than a twentysomething-year-old woman.

Although the eyeball may seem like the natural place to start, it's best not to begin there. Instead, draw the shape of the top and bottom eyelids. This will help to frame the eyeball and lock it in place. Note that the upper eyelid is always longer than the lower one and is also the one that makes the most dramatic arc.

Once the eyelids are in place, add the eyelashes. You can bunch them together so that they look like a single mass of black, or you can draw them as individual lashes. These are stylistic choices that are fun to experiment with. Don't forget the eye shines!

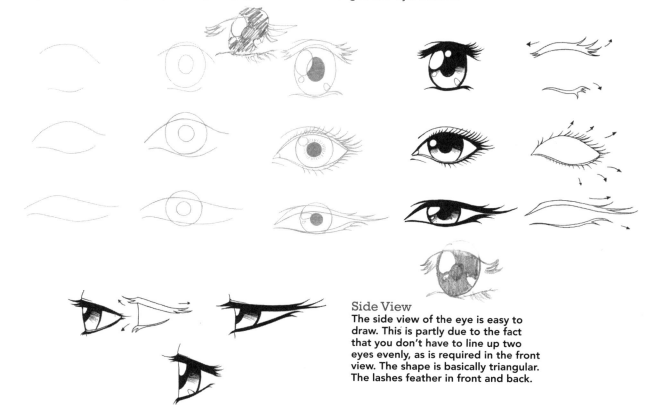

Side View
The side view of the eye is easy to draw. This is partly due to the fact that you don't have to line up two eyes evenly, as is required in the front view. The shape is basically triangular. The lashes feather in front and back.

Simple vs. Bold

Here, you can see the difference between clean, simple eyes, and those with a lot of lashes and eyeliner. Both are equally useful, depending on the type of character you draw. In general, more heavily made-up eyes are reserved for older, more mature characters, and instantly create an alluring, flirtatious look.

Simple

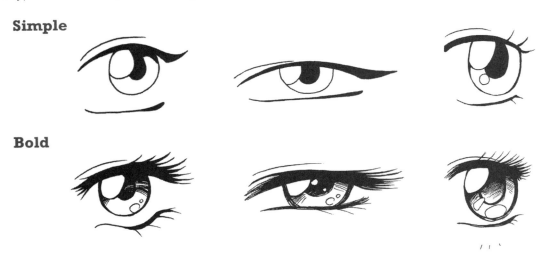

Bold

Romantic Male Eyes

There are many ways to draw handsome male eyes. The overall shape is more horizontal than vertical; it is narrow but long. The eyes also have pronounced shines. The eyelids look as though a bucket of mascara was applied to them.

The younger the character, the "taller" the eyes.

Bishies are more mature characters and have narrower eyes, like most older characters.

Notice how the eyebrows all trail off into thin lines.

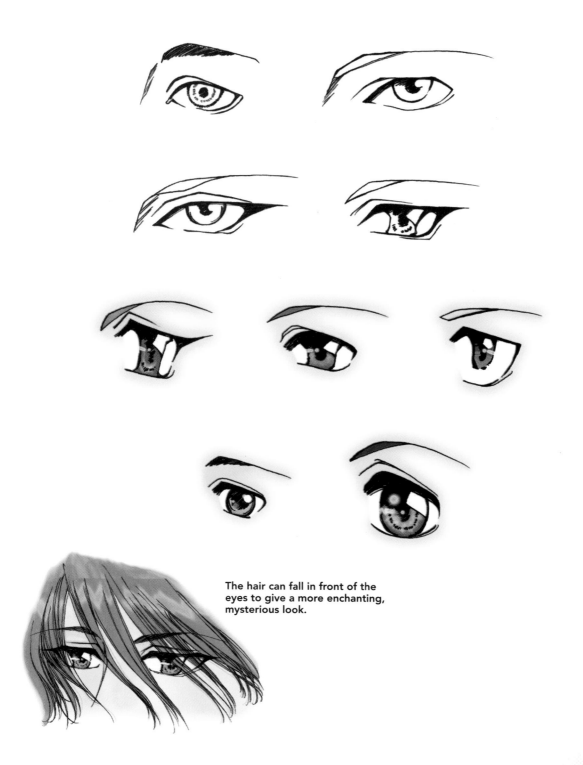

The hair can fall in front of the eyes to give a more enchanting, mysterious look.

Dreamy Facial Expressions

Now we bring the other features into the act! This section offers a wealth of specific expressions, along with the corresponding facial constructions. This not only allows you to understand how to create attitudes but will also help you to create interactions between your characters. And we'll also squeeze in some shoulder action when we can, for a little extra fun!

Girls

Of course, the eyes, eyebrows, and mouth are the primary movers in creating expressions. But for girls, there's more: Pay special attention to the shape of the eyelashes, elongating them on sultry or sad expressions. The hair also moves, reflecting the state of emotions, flailing about in a stormy manner when the character is angry. (We'll cover hair in more depth on page 16.)

Sealed with a Kiss
In a flirtatious expression, you always want to keep the lips curved.

Winking
This is a popular conceit and is used on playful characters.

Lonely

Shoulders rise up, as if trying to comfort her like a blanket. Looks of unhappiness usually have the eyes cast downward.

Emotional

Characters who feel their emotions deeply are fan favorites in manga, because young readers relate to their sense of vulnerability.

Daydreaming

Heavy eyelids capture a romantic gaze into the distance.

 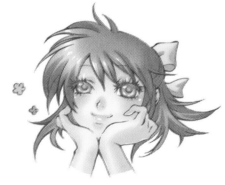

Chuckling

Never draw individual teeth. Meld them together for a brilliant look. (Note the high, arching eyebrows in expressions of laughter.) Closed eyes show her happiness. The expression, therefore, relies more on the eyes than on the mouth.

 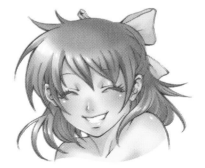

Boys

Boys can have expressions that are just as dreamy as those of girls, but their expressions can also become fierce and pretty intense; perhaps they're planning revenge on someone, or are vying for their crush's attention. Because the older teen boys don't have the huge, glistening eyes of the girl characters, you need to make the eyebrows do a little more work. The eyebrows are sharper and point downward toward the bridge of the nose. In addition, look for a tilt of the head to assist in creating an expression, instead of only using what's going on in the face itself.

Thinking
Thinking is always indicated with a look off into the distance and with eyebrows that press down on the eyes.

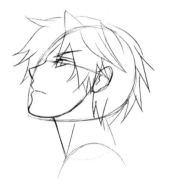 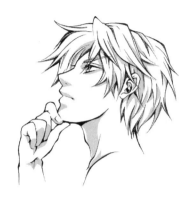

Caring Smile
Half-closed eyes give this character a sympathetic, dreamy expression.

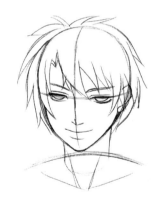 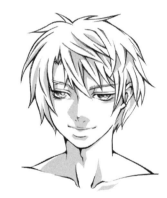

Brooding
A suspicious character may tilt his head down and scratch his chin as he tries to figure out what's going on.

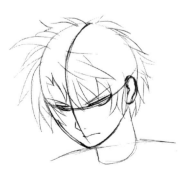 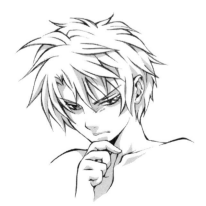

Crazy Laugh

The one eyebrow is raised, while the other crushes down, creating a dynamic expression.

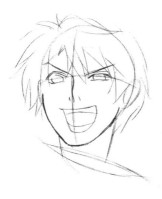

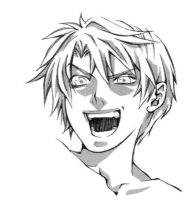

Reflective Smile

A downward head tilt adds a little spice to front-view poses. Don't make the eyebrows frown too much, or he'll look evil. Just a small downward angle does the trick. Shadow adds an element of mood to the expression.

Mischievous Smile

With the right attitude, you can almost tell what a character is thinking—perhaps not the exact thought, but whether his intentions are good or bad.

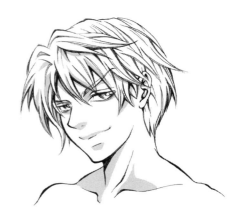

Adding Style with Hair

Second only to the eyes in their impact on the reader are the elaborate and extravagant hairstyles of manga. The hair is a key feature of the character's design, not something to be added after the fact. And it helps kick up the glamour in your drawings, since there are so many ways it can move, curl, and flip!

Pump Up the Volume

Whether the character is male or female, the hair must be abundant and full of body. Although not as long or quite as full as girls' hairstyles, boys' hairstyles are, nonetheless, still an impressive display.

Female Head Construction Without Hair . . .

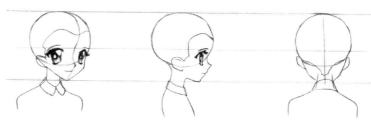

. . . And with Hair
Notice how much more space the head takes up once you add the hair! Make the hair big!

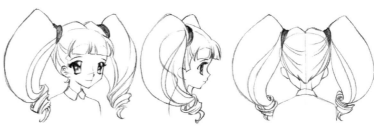

Male Head Construction Without Hair . . .

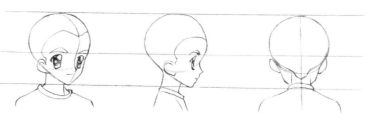

. . . And with Hair

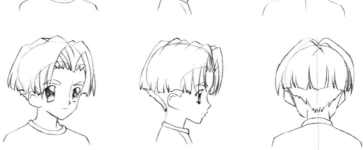

Sweet and Easy Hair

In manga, hair is usually is flowing, loose, and sometimes has a life of its own! This look is attractive and breezy, and captures the spirit of teen stories. When a manga character whips her head around because she's spotted her crush in the hallway, her hair reflects this.

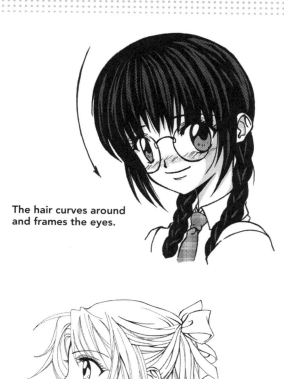

The hair curves around and frames the eyes.

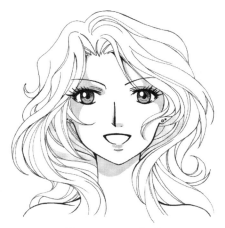

Elegant waves look great on a night out.

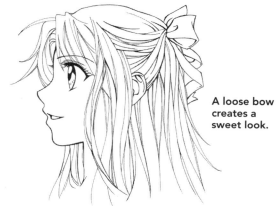

A loose bow creates a sweet look.

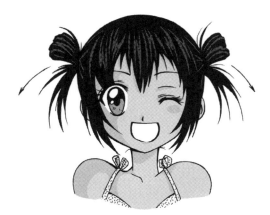

Cropped ponytails—or ponytails that aren't pulled completely through the elastic band—are a very cute look!

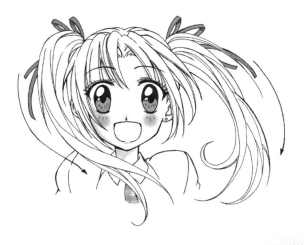

Creating Movement with Hair

Instead of thinking of hair as inert, just lying there on the head like a hat, think of it as strands traveling purposefully in a direction. This gives it a dynamic quality and keeps it from looking subdued.

Plus, have you ever noticed that manga hair on female characters often seems to blow in the wind or move gracefully in a swirling action? This flourish adds charisma and is an eye-catcher for the reader.

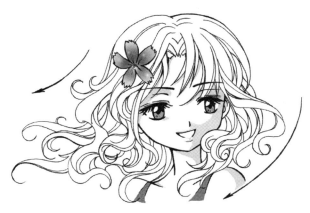

Flowing Curls
This hair is bunching and curling—and also moves from one side to the other. Very romantic!

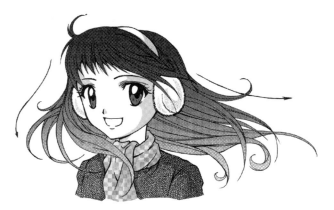

Windblown hair moves both in front of and behind the head. Note that individual strands are drawn, which makes the hair-style more elegant and appealing.

Ponytails
These are magical girl-style ponytails that swirl and twirl.

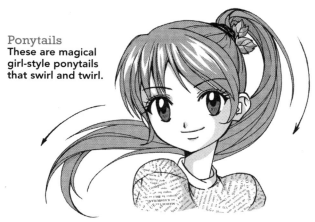

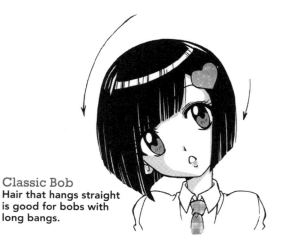

Classic Bob
Hair that hangs straight is good for bobs with long bangs.

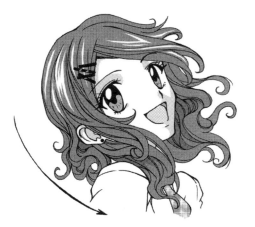

Here, the hair blows from the back to the front, curling at the ends.

Handsome Boys

Good-looking guys can be so vain; it takes a lot of effort to make your hair look this natural and carefree. Here are a few of the most popular hairstyles for the romantic set. Long hair is very popular. But even when the hair is short, long strands of it should fall in front of the face. Don't draw the hair perfectly combed and in place; this makes the character look too restrained. Add a little action to it, as if it's slightly in motion. This makes for dramatic, movie-star looks.

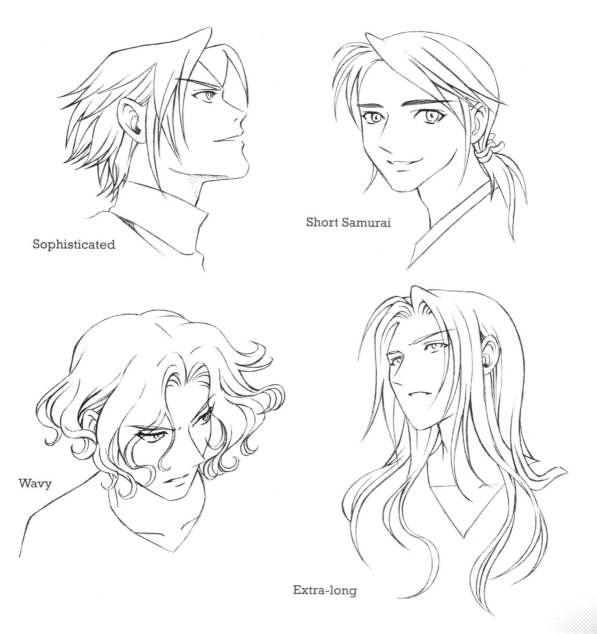

Sophisticated

Short Samurai

Wavy

Extra-long

Charming Flowers

Flowers are used throughout manga as symbols to convey the mood of a scene. Dreamy scenes, love scenes, and happy scenes can all be decorated with flowery backgrounds to enhance and communicate imagination and good feelings. And, of course, flowers are given as tokens of affection.

Flowers and plants are particularly charming in chibi stories. Often, the center circle of the flower has a simple face with a happy expression. Roses are the most common type of flower used in manga, but many others also appear. And you can even invent your own types! Try to create flowers that reflect the mood of the scene and characters.

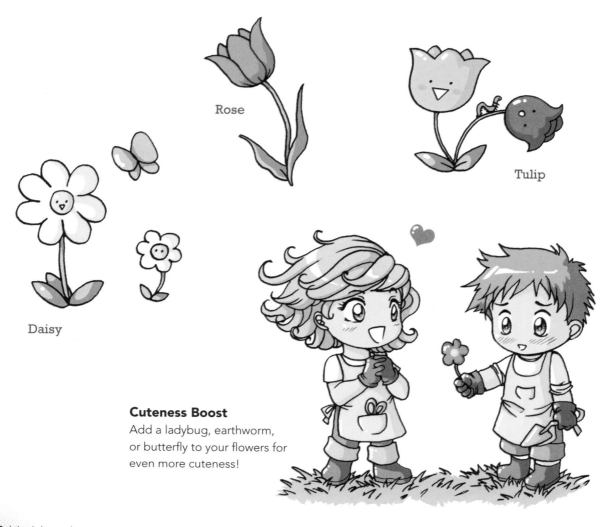

Rose

Tulip

Daisy

Cuteness Boost
Add a ladybug, earthworm, or butterfly to your flowers for even more cuteness!

Body Language

Creating Synergy

Eye contact certainly helps when trying to communicate the attraction between two people, and we'll get to that on the next page. But sometimes, two people who like each other try not to look at each other, for fear of being too obvious. And eye contact alone can't sustain that heat across numerous panels of manga. No, there's more to it than that—a lot more.

Attraction is like gravity: the closer two objects are to each other, the stronger the pull. Two characters sharing a park bench for a chat won't ignite any sparks if they're too far away from each other. But closer together, the chemistry starts to happen. So, before you worry about eye contact, pay attention to the distance between your characters.

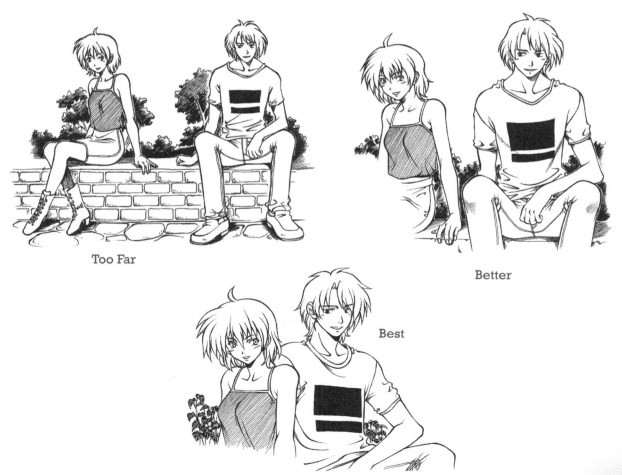

Too Far

Better

Best

Eye Contact

Now that your characters are a bit closer together, have them lock eyes. A deep stare, straight into each other's eyes helps put them on the same wavelength, emotionally, and establishes a bond between them.

Making eye contact doesn't require two characters to face each other, especially if it's an initial meeting. It's more inventive—and more natural— for people to initiate eye contact without committing themselves entirely. There must be some hesitancy, either from him or her. And that should show in the oblique way you position the characters in relation to one another.

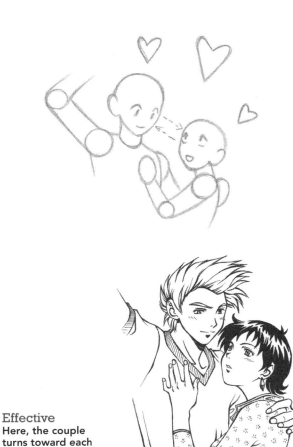

Ineffective
Here, the couple looks off in opposite directions. There's no connection.

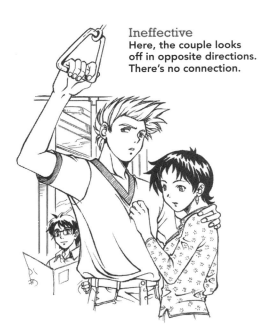

Effective
Here, the couple turns toward each other and you can see the chemistry between them.

Eye Contact & Character Positioning

Regardless of how characters are positioned, eye contact brings them together. Even if you place two characters relatively far away from each other, if they are looking into each other's eyes, the viewer will know there's a special connection between them.

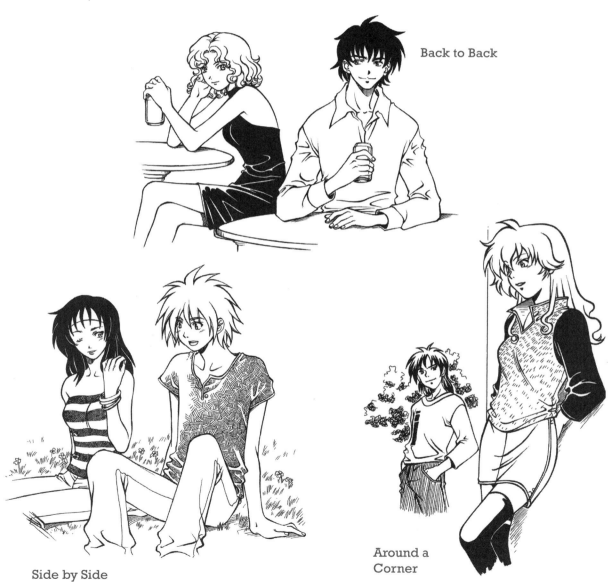

Back to Back

Side by Side

Around a Corner

Getting Close

There are many ways that you can demonstrate playful dynamics between characters. It doesn't have to be dramatic. Sometimes, it's just a cute sign of friendship. Here are a few examples of subtle ways to make the interplay between characters a little more interesting.

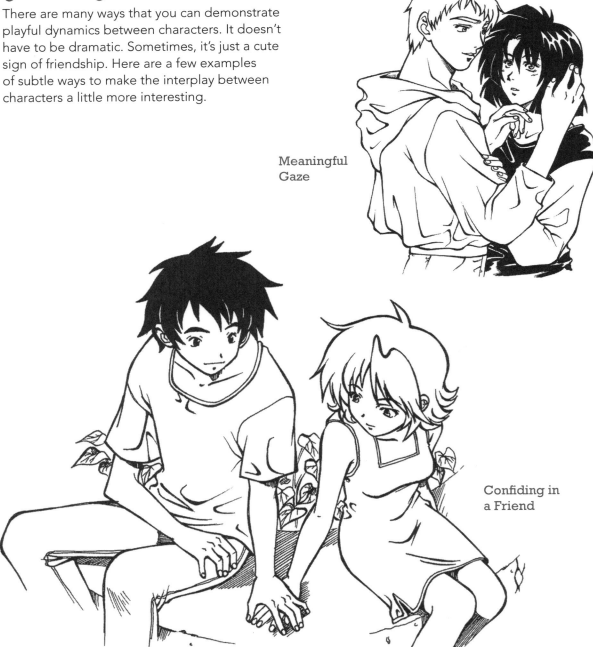

Meaningful Gaze

Confiding in a Friend

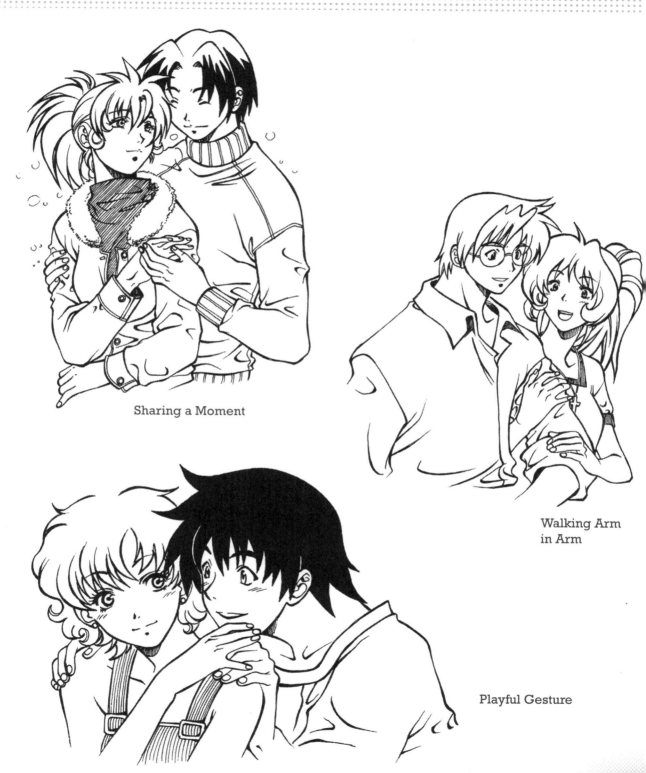

Sharing a Moment

Walking Arm
in Arm

Playful Gesture

Victorian Inspiration

Ah, the Victorian Age. Fair ladies and dashing young men. No one wore jogging pants and Nikes. You wore so many layers that a servant had to dress you. This style, often found in occult or horror manga stories, brings elements of glamour and mysterious flirtation to stories. Try dressing your characters in these Victorian-style outfits to heighten the sense of sophistication and intrigue between them.

Gothic Wedding

Here, we have a Gothic bride and groom. They seem dark and mysterious, but she smiles at him, and he tips his hat to her, indicating their affection for each other. Regardless of what two characters look like, you can always convey chemistry between them if you focus on body language.

These characters maintain the elegance, poise, and style of their mysterious forebears, but they are decidedly modern. Their clothes are still ornate, with traditional touches, but are also macabre. The characters are brooding and lean, which adds up to a more dangerous and usually attractive look.

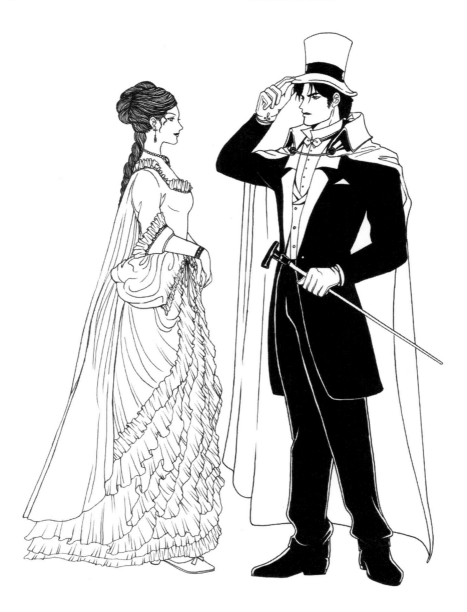

Romantic Humor

Love doesn't have to be so serious. It can be cute and funny, too. And what better characters to illustrate this than the adorable chibis of manga?! (Of course, these principles will work on any manga characters.) We want these chibis to interact to create humorous situations. The key to creating humor is to show two characters working as a team but each having a very different experience.

Clashing Reactions

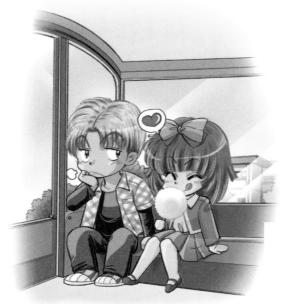

One-Sided Crush
There may be a ton of empty seats on the bus, but she has zeroed in on her guy! She's just happy to be there, sitting next to him with nothing to say, just eating cotton candy while he's bored out of his wits.

The Unexpected Kiss
He could have had a happy reaction instead, but that wouldn't have been as funny. The stunned blush is a perfect response. And she's oblivious, unaware of the emotional havoc her one little peck on the cheek has caused. Two people, one kiss, but two totally different reactions.

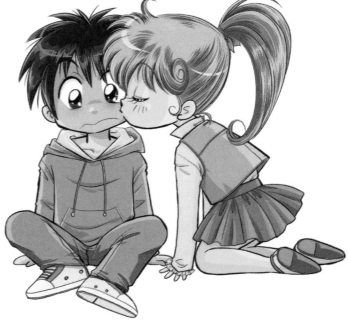

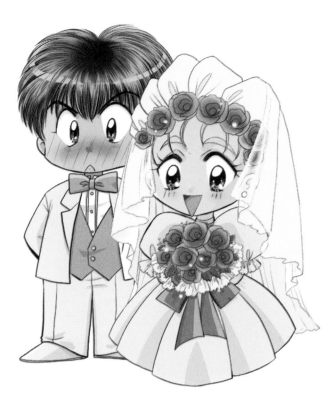

What Have I Done?

Again, it's the classic setup when two characters are sharing the same moment but reacting very differently—and only the reader is in on it! In a scene like this one, it's important that both characters look straight ahead. If they were to look at each other, they would see what the other is thinking and the moment would be over.

Innocent Fun

Outdoor Adventures

One character is engrossed in the action, while the other character breaks to wink at the reader. Manga uses this type of reality break a lot. With other styles of cartoons and comics, the result of a "nod" to the reader can be jarring. But with manga, it brings the audience into the story and closer to the characters.

Sharing a Snack
In a dramatic scene, everything looks edgy and off balance. But comedy is often symmetrical, and this picture shows how balance can be funny.

Mischievous Couples

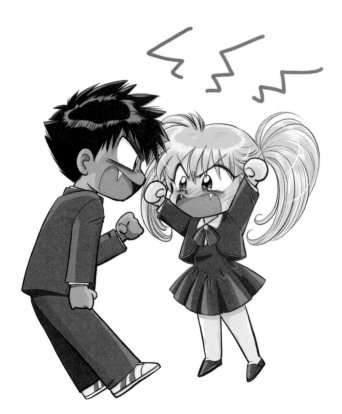

Lover's Spat
It looks like someone got stood up on a date. Aren't arguments fun? Two little powder kegs going at each other with explosive tempers. You can tell this couple is fighting because of their clenched fists, steep brows, and teeth that have turned into fangs! Actually, this is exactly what happens to normal-size characters in manga stories when they go ballistic during arguments—they "turn chibi." I'm sure they'll make up soon.

Hey, Cut It Out!
This is his backward way of showing her that he likes her. Open her eyes in a surprised look rather than a look of pain. Pain that's made to look silly can be funny, but if something looks like it really hurts, someone might think you're heartless for poking fun at it.

How to "Chibify" a Character

Any character can easily be turned into a chibi version of itself. When you make this transformation, think *over-the-top*.

The chibi head is proportionately larger in relation to the chibi body than the standard-size head is on regular manga characters. There's even more hair. The forehead gets larger, as do the eyes and the eye shines. The eyes also move down lower on the face. The bridge of the nose disappears. The cheeks get chubbier and the mouth narrower. Any lips that are shown disappear. The chin gets rounder, and the neck becomes very thin.

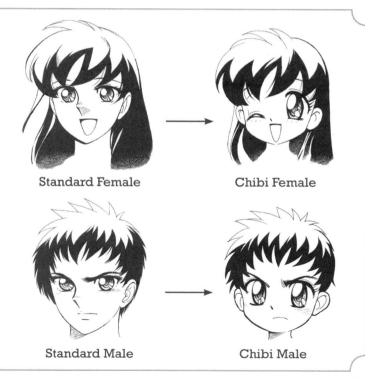

Standard Female → Chibi Female

Standard Male → Chibi Male

Sweet Settings

Let's take a look at locales. It may seem secondary, but the right setting adds a sense of charm, as these images show. You want your scenes to have a familiar feeling—to be more accessible to the reader. Keep it cute and simple. Even if you're not drawing in a more elaborate style, these are classic settings that can be adjusted for any genre of manga, and work well for stories that involve romance.

Home

A chibi never lives in a Tudor-style, three-story mansion. Instead, chibis live in cute and modest cottages with curtained windows and a front door with flowers on either side. This is a very inviting scene. There's a working chimney puffing out a harmless stream of white smoke. The walkway cuts through a manicured lawn punctuated by a tiny mailbox. Is there a little picket fence around the property? I'll give you three guesses.

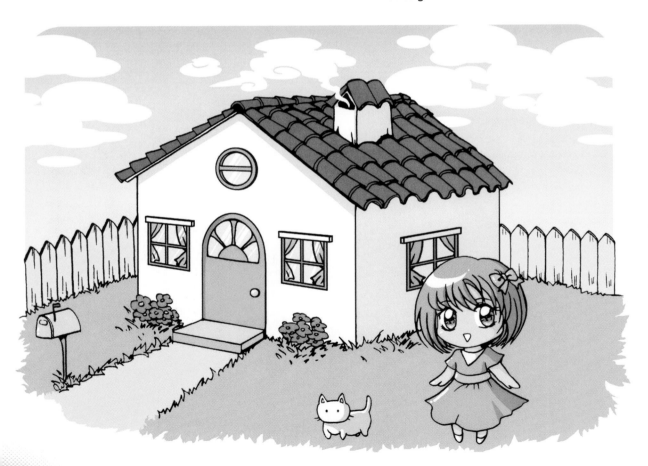

School

Because so many manga stories take place at school, it's only fitting to include a school here. Consider making the lines of the building curved rather than ruler-straight; this keeps the building cartoony and cute. And one note: Schools often fly a flag on a flagpole, but since manga and graphic novels get translated so often into different languages, you'll want to avoid choosing one nationality, because it would make readers from other countries feel left out. Best to eliminate the flagpole entirely.

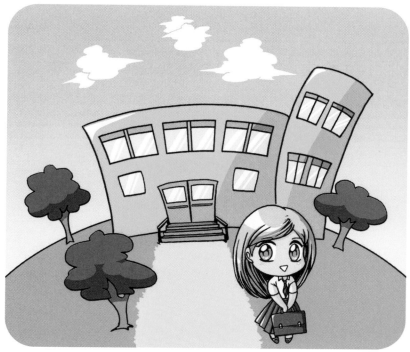

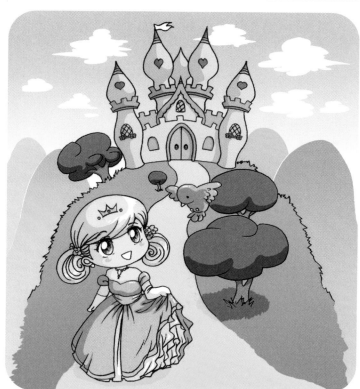

Fantasy Locales

This princess is just waiting for her prince. Note that the castle, like many real castles, is perched atop a hill, which gives it a nice juxtaposition against a cloud-dotted sky. The turrets have spires on top that come to a point; these are highly fanciful and dreamlike. The heart motifs add to the feeling that this character is looking for love. A wavy lane ambles all the way from the entrance to the foreground, adding a storybook type of perspective to the illustration.

PART TWO
Let's Draw It

Meeting Up

These two characters are in the 3/4 view, which is a natural, very common approach for portraying characters interacting with each other. Here you can also see the differences between the male manga figure and the female manga figure. This guy's shoulders are a little wider than his hips, and his body has been constructed from very straight lines. The girl, turned toward him, is drawn from more curved lines. Based on their body language, you can tell there's a bit of chemistry between them!

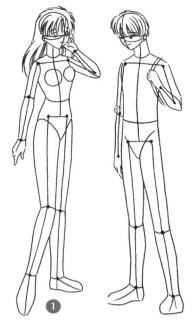

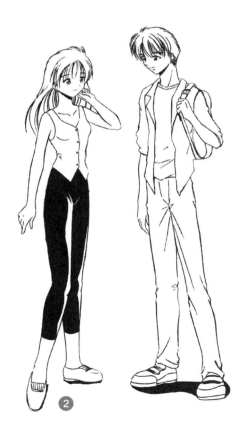

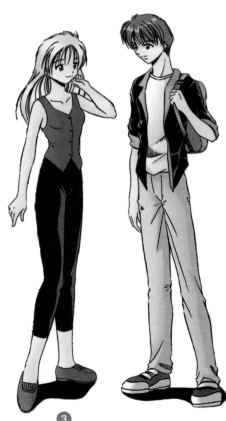

Handsome Heartthrob

Every story needs a handsome male lead—someone the girls will fawn over. This character fits the bill perfectly. One of the main differences between the younger teen boy and the older teen boy is that the younger ones never wear suits or trendy clothes. They're just not as dapper as their more mature counterparts. Pose the older teen characters so that they look casual and comfortable in their stylish clothing.

Something to note about this pose is that the upper body twists toward the reader, while the lower half of the body twists away. This adds tension to the body, which brings energy to the pose. Always look for a way to use posture to invigorate your seated poses.

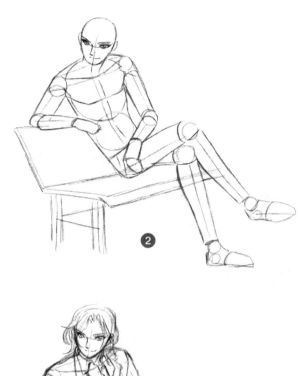

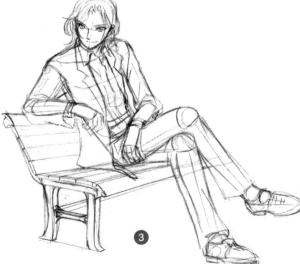

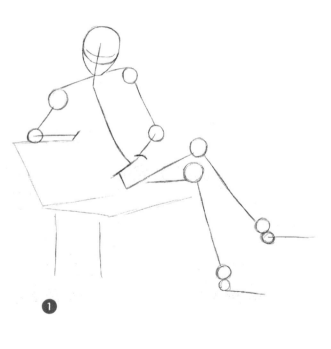

A Note about Shadows

Shadows don't have to be precise to be effective. Just mirror the general shape. Also, they don't have to be black. You can choose a color. But if you do make them a color, be sure that the tone you choose remains muted enough to fade into the background. Don't allow the shadow color to compete with the character.

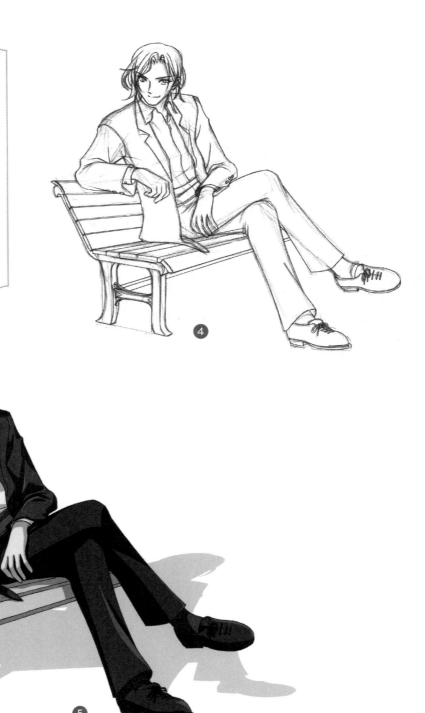

Favorite Teacher

Although not a teen, the good-looking teacher shows up as a favorite character in lots of shoujo stories that take place in high school, so we don't want to leave him out. He's got a dedicated group of fans, no matter what he's teaching. His breezy style and unassuming pose make him an attractive character. The sports jacket is necessary to give him some sort of grown-up attire. The crew-neck shirt replaces the collar and tie to give him a more youthful look. Glasses and a middle part are used to indicate his intellectual prowess.

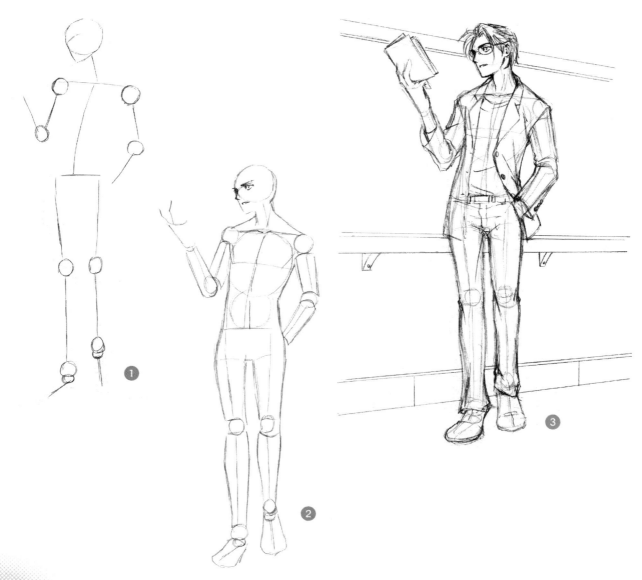

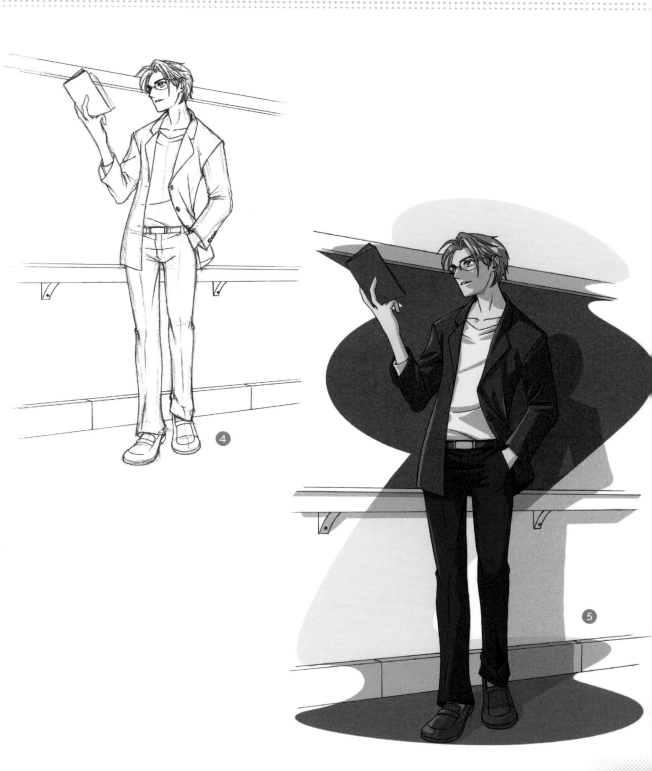

Going to the Ball

These two Victorian characters could be heading to the Baron's annual ball at the castle, where the Who's Who of high society are in attendance. He has his hand outreached to his alluring date, but it looks as though she pulls away from him slightly.

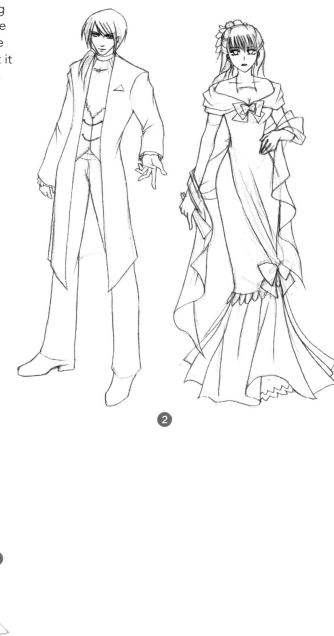

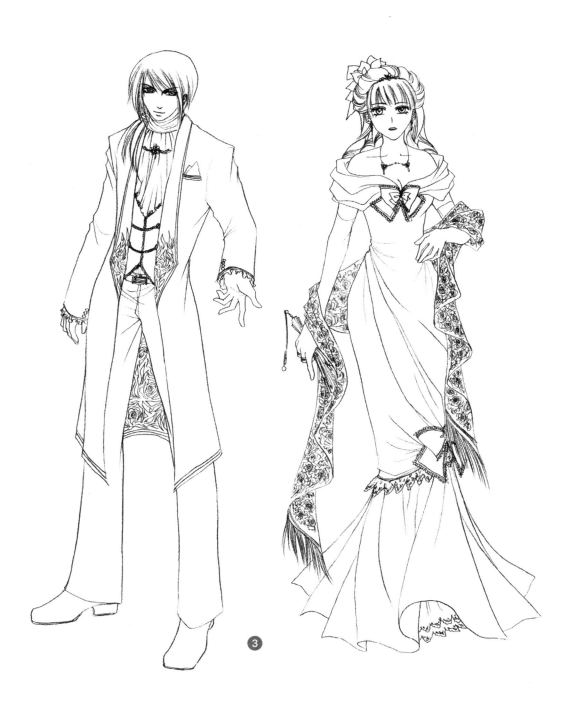

Waiting for Her Date

This is a fun, carefree pose. As the teen leans back, she holds onto the railing. Note that she is actually leaning forward at the waist but tilting backward on her feet, which causes her bottom to stick out. Use this pose when a character is acting playfully or looking expectant.

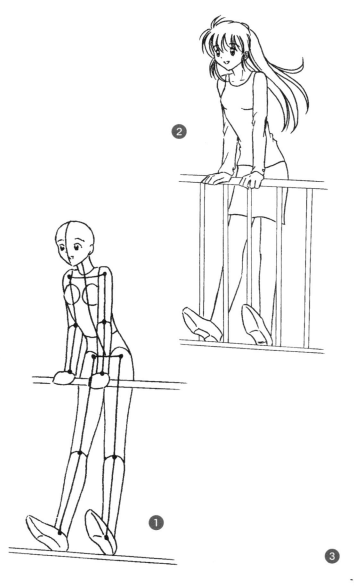

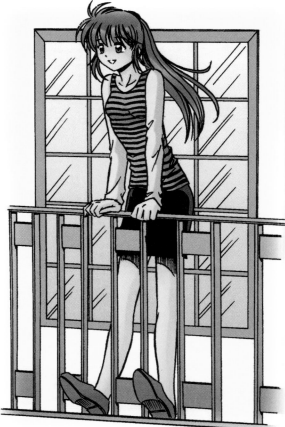

Fighting Over the Girl

Two guys. One girl. This could spell trouble. This picture is drawn on a slight diagonal: The vertical lines of the building are slanted, as are the people. This is called a *tilted frame* and is typically used to heighten the dramatic tension within a scene.

In addition, the entire scene is drawn in a predominantly vertical fashion. Notice how the characters and building are positioned vertically—there's nothing going on horizontally. This type of composition allows you to place numerous characters in a small space within a fairly close shot, without making it look like a tight squeeze.

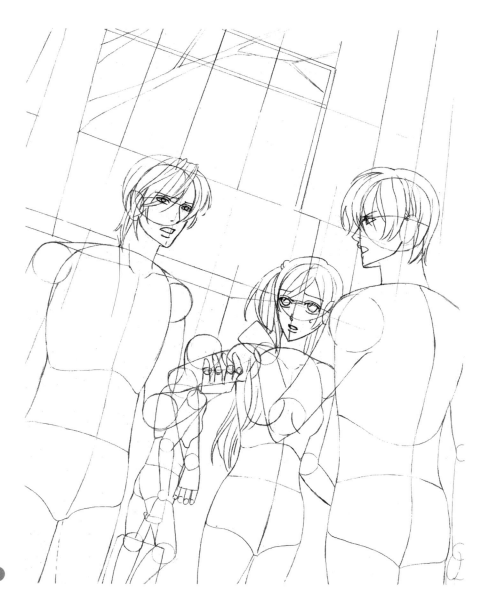

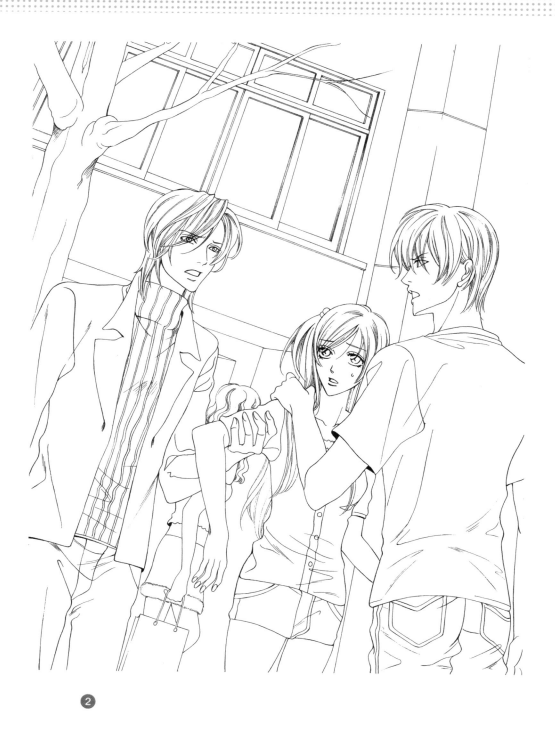

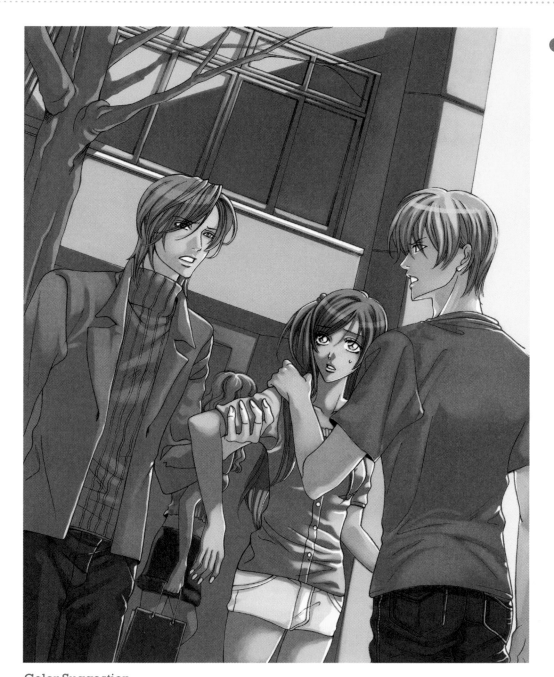

Color Suggestion

Here, the skin color is reflecting the emotional state of the charac-
ters, which is getting hotter. The skin tone has more orange in it,
making it fiery, dialing up the degrees of the scene a notch or two.
Likewise, the building is yellowish and purple, giving it a baked
look. Temperatures are rising, and soon something is going to
explode. In this way, colors can reflect the tension of a scene.

Having a Party

We're having a party . . . and who invited those guys? These friendly party crashers don't take no for an answer. They simply flash their smiles and hope their charm does the rest. Notice how the eye moves from the boys counterclockwise to the girls on the couch, then to the girl standing by herself, and then back to the boys again. In other words, the placement of the figures encourages the eye to make a continuous loop, which keeps your eye within the panel.

In addition, there's a lot of overlapping that occurs here, which creates a sense of depth: The girls on the couch overlap the two boys entering the room, and the girl on the right overlaps the table. All of this creates a nice foreground/background dynamic.

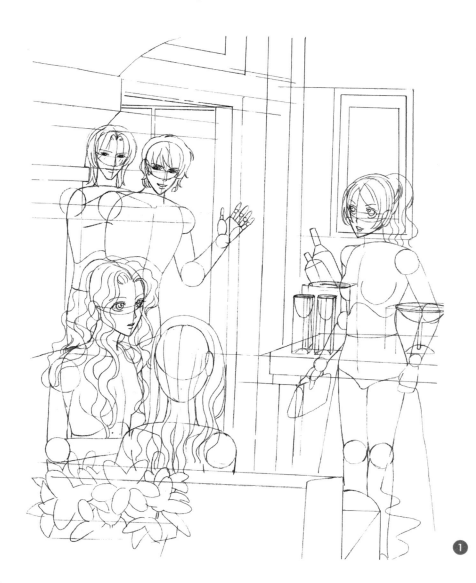

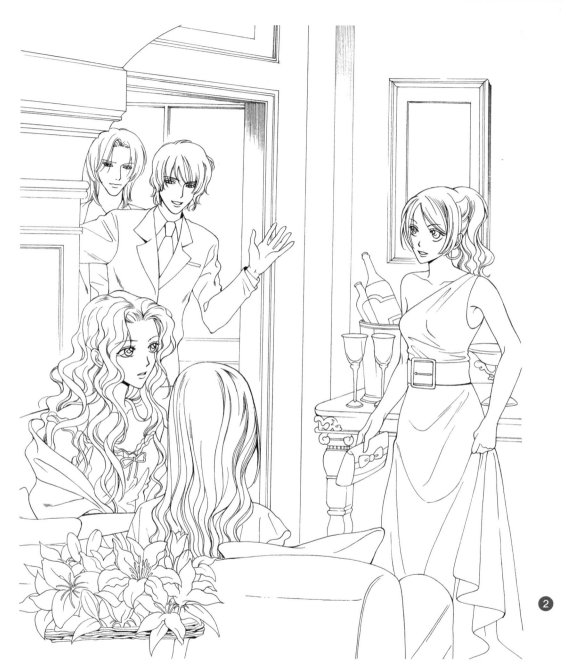

"Dress up" is part of the fun of shoujo manga, and readers love to see it. It's a world filled with fancy clothes and stunning locations. Readers thrill to live vicariously through their favorite characters. Whether they drive a million-dollar exotic car, wear outrageously expensive clothes, or jet-set to exotic resorts, our characters live the lives about which we can only dream.

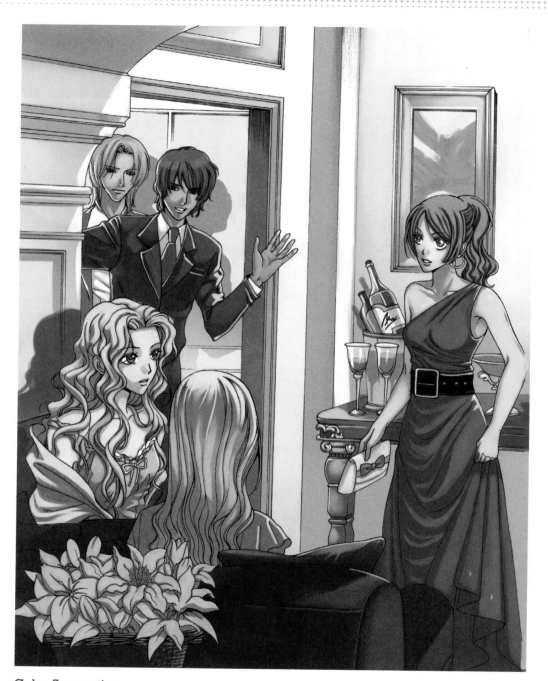

③

Color Suggestion
Which girl's party is it? The brunette, of course. Why? Because she's the one wearing the red dress. The bold primary color, instead of a muted or pastel tone, makes her stand apart from the other girls, and even the guys. The vibrant red underlines her role as the main figure on the page.

School Dance

We've got a silly couple in the middle of the dance floor, bookended by two other couples on either side. This forces the reader to notice the couple in the middle.

This is a funny situation in which the two main players are each having different experiences but sharing the same action: dancing. She's dancing modestly, whereas he's dancing up a storm.

We get the feeling that she hardly knows this guy, yet his electrified hair shows that he's already deeply in love! Turning the dancing gal's head so that she glances over her shoulder lets the reader see both dancers' faces. She might be figuring out how to make a break for it—or just focusing on her dance steps!

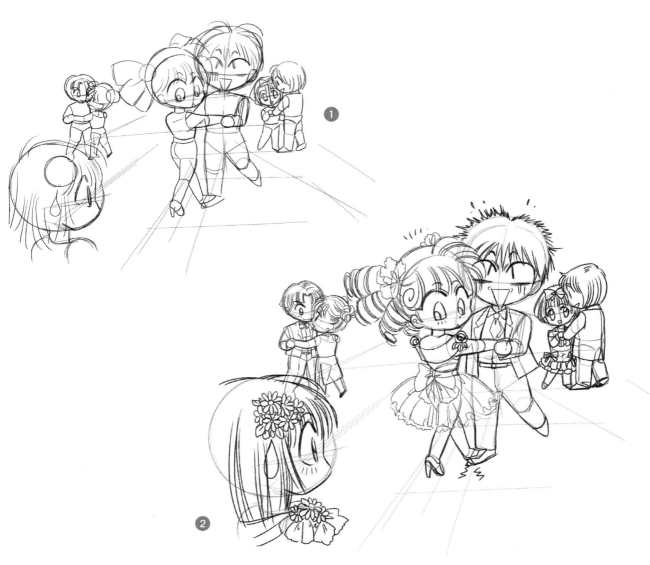

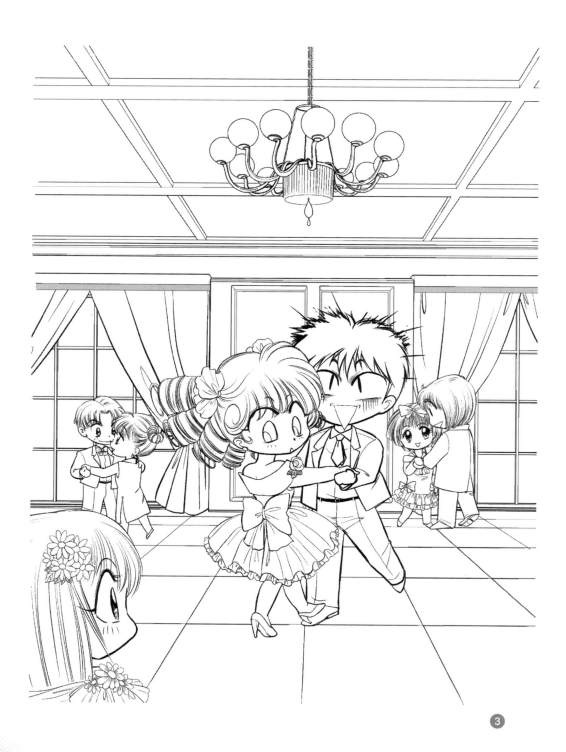

3

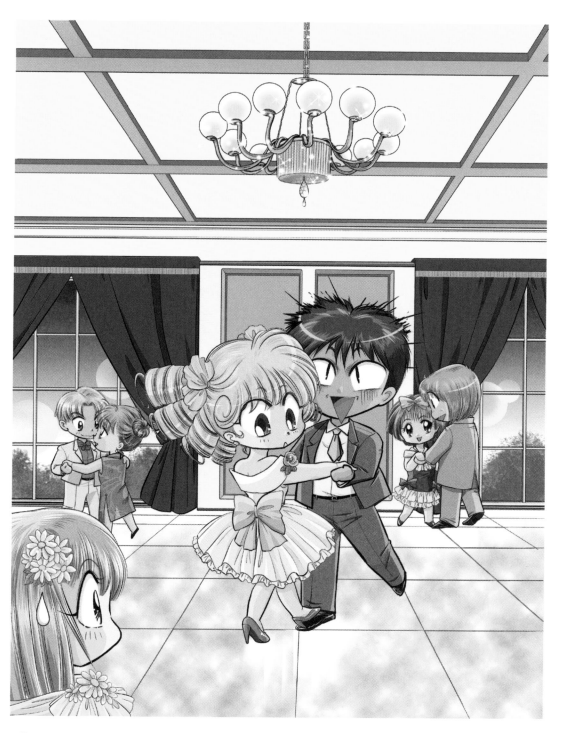

4

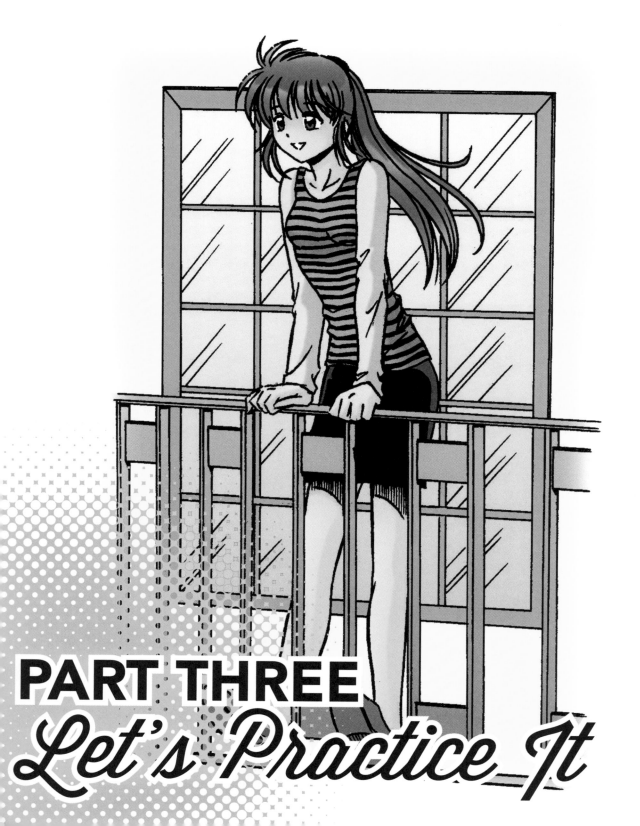

PART THREE
Let's Practice It

Practice copying these romantic-looking eyes. Then, try drawing some on your own.

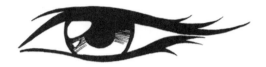

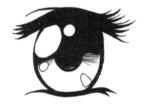

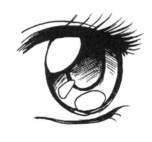

Draw the face on this girl, making her wink.

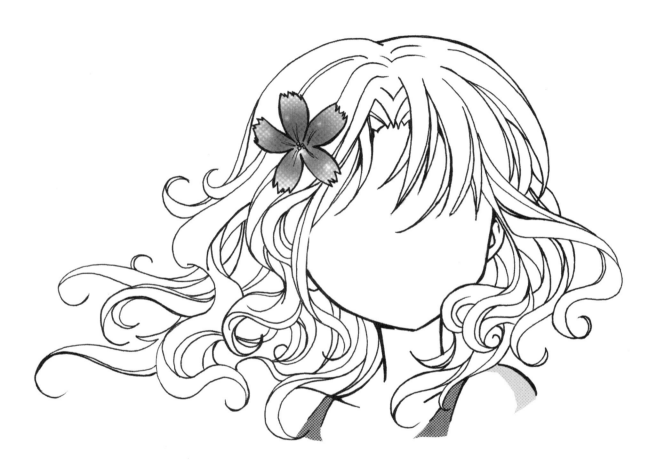

Draw a dreamy expression on this male character.

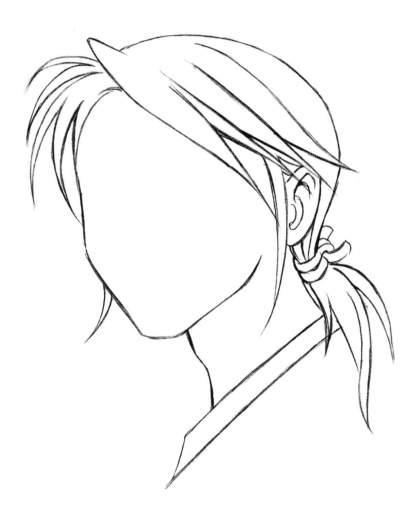

Who is this girl daydreaming about?

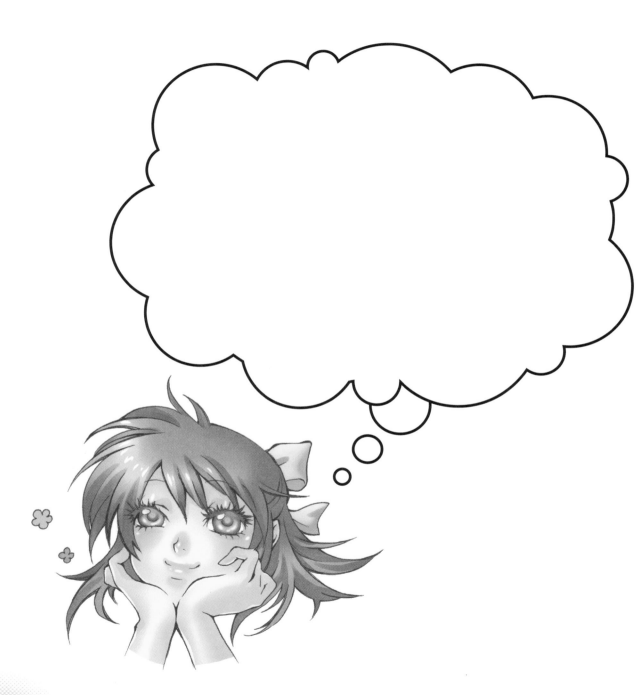

Who is catching this manga guy's eye?

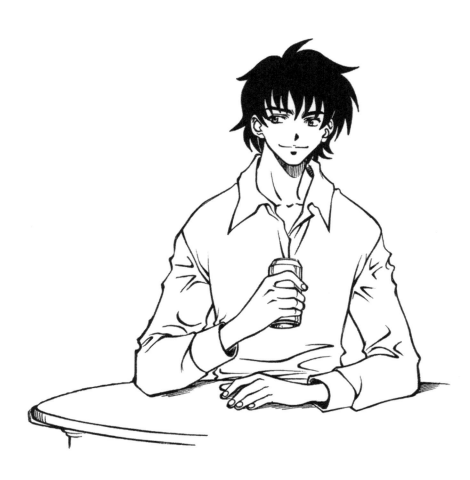

Embellish this girl's look with flowers, a cool hairstyle, the works!

Draw a manga friend that would be a good match for this girl.

Draw a manga crush that would be a great match for this guy.

Draw in a dreamy locale that's just right for this chibi.

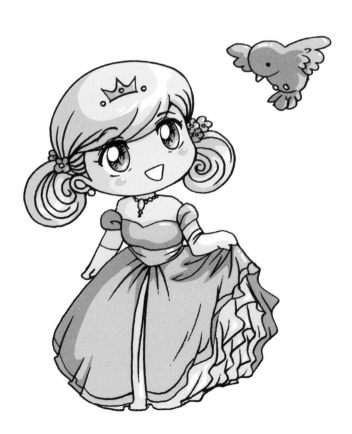

Who is this chibi giving a flower to? Can you add in some extra flowers around them, to add to the scene?

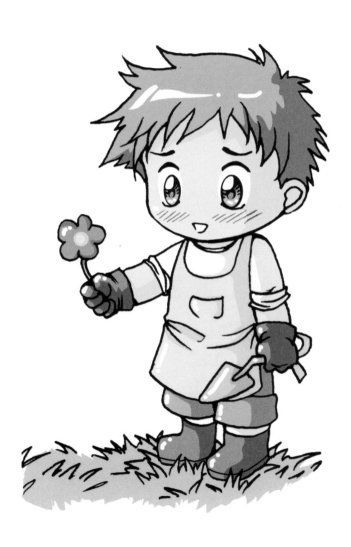

Finish this scene—add in some other chibi pairs, and give them some snowy slopes!

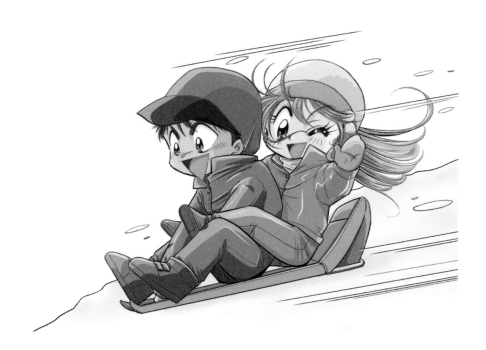

Also available in *Christopher Hart's Draw Manga Now!* series